START
Calligraphy

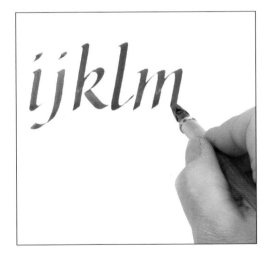

Maureen Sullivan

ΛBCDE

ABCDEFGH

ijklm

START

Calligraphy

All the techniques and tips you need to get you started

Maureen Sullivan

Search Press

Previous edition published in 2005 by Search Press
under the title *Craft in Motion Calligraphy*

This edition published in Great Britain in 2010 by
Search Press Limited
Wellwood, North Farm Road
Tunbridge Wells, Kent TN2 3DR

Created and conceived by
Axis Publishing Ltd
8c Accommodation Road
London NW11 8ED
www.axispublishing.co.uk

Creative Director: Siân Keogh
Editor: Anna Southgate
Design: Simon de Lotz
Production: Bili Books
Photography: Mike Good

ISBN 978-1-84448-638-0

Suppliers
If you have difficulty in obtaining any of the materials and
equipment mentioned in this book, please visit the Search Press website
for details of suppliers: www.searchpress.com
Alternatively, you can write to the Publishers at the address above, for a current
list of stockists, which includes firms who operate a mail-order service.

Printed in China

Contents

Introduction

All writing has evolved from art. The earliest known records of human activity are the pictures that cave dwellers drew on the walls to commemorate the hunt. Gradually, over 20,000 years, pictures became simplified in form and more symbolic, such as the pictograms or ideograms of the Sumerian cuneiform writing system and Egyptian hieroglyphics. The first Western alphabet representing phonetic sounds was written on clay tablets by the Phoenicians about 2000 BC. As the centres of power shifted around the Mediterranean, the Greeks, Etruscans and later, the Romans modified the alphabet to comprise 23 of the letters that we recognise today. Later, as written language developed, the letters 'J', 'U' and 'W' were added.

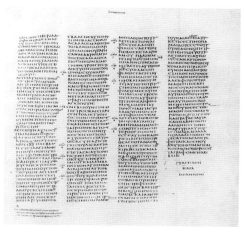

Greek codex, 4th century
Codex is the earliest form of book, written with a quill on pages made from parchment (sheep- or goatskin) or vellum (calfskin). The pages were bound between wooden boards.

parchment and pen

The Romans used three different writing scripts: a stylus on wax tablets and clay; a chisel on stone to carve the classic capitals, beautifully proportioned and still an inspiration, on monuments and public buildings; and a chisel-shaped brush or reed to write the rustic capitals. As the armies of Rome spread across the world, so too did Roman literature. In 311 AD, the Emperor Constantine began urging the spread of Christianity. The Bible became the first codex bound as a book, made with parchment or vellum pages, written with a quill in the round circular uncial hand (a curved hand of unequal height as used in Greek and Latin manuscripts).

The Irish developed a half-uncial hand and wrote the Book of Kells and the Lindisfarne Gospels were completed in 698 AD in Northumbria.

In 789 AD, Charlemagne, King of the Franks, wanted to unify many peoples, cultures and languages under one language, Latin and one writing script. He dispatched Alcuin of York, along with a team of scribes to Tours, France, to develop the Caroline minuscule, a clear rhythmic writing that remained the dominant script for centuries. The English monks who wrote the Ramsey Psalter, an elaborate 10th-century codex, developed the most legible script, the letters are round and clear and were later rediscovered by

Edward Johnston in 1900. He modernised it and called it the 'Foundation' hand.

As medieval architecture became taller, pointed and more angular, the shape of letterforms such as gothic, blackletter and texture came to reflect this fashion. Later, in the 15th century, Gutenberg made moveable type, which used gothic letterforms handcut from wooden blocks. This type was used in printing the first Western books. In the 20th century, letter and type designer Rudolf Koch carved Blackletter shapes into metal, while today, Hermann Zapf designs digital fonts.

classic texts

As written correspondence became more widespread, a faster form of writing had to be found. In the 16th century the italic hand was developed using an elliptical 'o' and a greater economy of movement that allowed letters to be joined together. Among others, Lodovico Arrighi (1520) and Giovanni Battista Palatino (1544) wrote copybooks that inspire us as much today as they did their royal patrons at the time. This popular calligraphy has many variations, chancery cursive, formal, flourished, compressed, pointed, swash, handwriting, sharpened, gothicised and is now used internationally.

To cope with ever greater demands for printing, the copperplate replaced wood-cut blocks and mass printing closed many scriptoria. The new form of engraving used a pointed tool called a

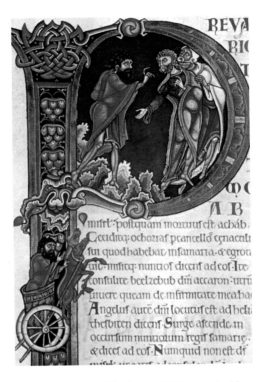

A page from the Winchester Bible, created in England c.1160–1180
It was written by one scribe on 468 pages of parchment and illuminated with 54 large initials, such as the letter 'P' shown here, which were drawn by at least six different artists. It remains today in the library of Winchester Cathedral.

burin to incise the copper and it became possible to print more copies with finer detail on paper. The pointed, flexible metal pen now replaced the 1,500-year-old broad-edged quills and reeds. At the end of the 19th century, William Morris, concerned that many traditional skills would be

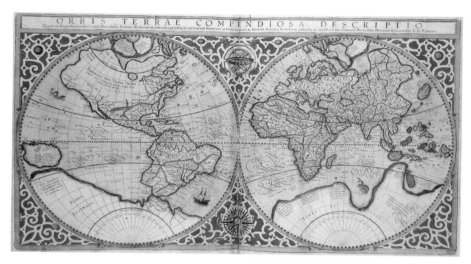

ORBIS TERRAE COMPENDIOSA DESCRIPTIO

A 16th-century Mercator map
Named after the famous cartographer, Gerhardus Mercator, Mercator's maps were masterpieces of intricate design and calligraphy.

lost, started the Arts and Crafts Revival in Britain. His secretary, Sydney Cockerell, encouraged Edward Johnston to study medieval manuscripts in the British Library. Johnston rediscovered the broad-edged pen and writing techniques of the medieval scribes. In 1899, he gave the first 'lettering' class in the world and in 1906 published *Writing, Illuminating, & Lettering*, which is still in print today and is the most widely sold book on calligraphy. In 1916, Johnston was commissioned to design lettering for London Transport's underground and buses. This letter style became the first sans-serif type.

The present revival of calligraphy across the globe owes much to Johnston's genius, philosophy and masterly use of the broad-edged pen, reminding us all that writing by hand in a beautiful style is both rare and precious.

calligraphy today

Calligraphy is, quite literally, beautiful writing. The word itself comes from the Greek *kallos,* meaning beauty, and *graphia*, meaning drawing or writing.

Most people take up calligraphy because they want to create something with their hands. Art classes, such as drawing, may feel somewhat daunting, whereas writing, which we all learned at school, feels more attainable; you don't have to be particularly artistically talented to enrol in a calligraphy class.

Calligraphy is an interesting and deeply satisfying activity. The materials, pen, ink and paper, are relatively inexpensive. Beautiful writing has practical applications, too, such as addressing envelopes and making cards for birthdays, anniversaries, graduations and so on. It can also be used, as it has been throughout the centuries, to add names to certificates, awards, diplomas, marriage certificates and family trees. Making gifts, such as boxes and decorated books, is another application, as is more formal work such as

creating pieces of art by combining words and images for exhibition purposes.

Calligraphy's status in the Western world as a recognised genuine artistic activity is growing fast, while in the Orient, it is respected as one of the highest traditional art forms.

Calligraphy invites you to find the perfect words. Whether it is poetry, stories, jokes, a few favourite lines from a play, novel or a song, words come to life with a calligrapher's pen. A whole new world opens up as we explore our thoughts and memories, as well as the canons of literature, in search of the right words.

Many people use calligraphy to express their thoughts and feelings and connect with their inner self. By committing these personal thoughts to a diary, letter, journal or scrapbook, they can share them with others. Calligraphy is also ideal for personalised letters and greeting cards. Imagine the excitement a person experiences at seeing the package they've just received. Though the words are to be read and enjoyed, a great deal more is being communicated. The card design, choice of paper, style of calligraphy and colours all deliver the message: 'I care enough about you to spend the time and effort to make this'.

Calligraphy also brings a sense of inner calm. The physical act of holding a pen and feeling it move across the paper is a unique pleasure. Writing, drawing and painting demand full attention and concentration, a balance between control and freedom that creates a meditative, peaceful state as you immerse yourself in the act of creating. So pick up your pen and lose yourself in this beautiful activity.

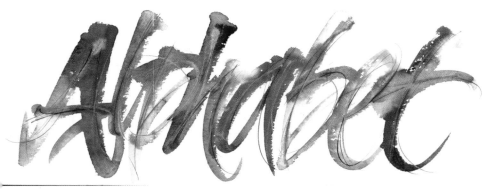

Alphabet
Rachel Yallop
Coloured inks and gold gouache on heavyweight watercolour paper using a large brush and pointed steel nib.

Pens and nibs

The pen is the most important tool in your calligraphy kit. Its origins stretch back over 1,500 years to the reed and quill used by the early Christian monks to produce their illuminated manuscripts. Modern pens try to replicate this style, allowing ink to flow simply over a nib.

Pens come in a number of shapes and sizes for creating a wide variety of lettering styles. The simplest, and most widely used, are called 'dip' pens and come in two parts – a penholder (the barrel) and a nib.

penholders and nibs

Try out several penholders and see which ones fit your hand the best. Whichever one you choose should feel comfortable and well-balanced. Check to see that the nib fits snugly in the end so that it doesn't move around as you write.

The nib is detachable so any number of sizes can be inserted into the same penholder, without the need for owning a large number of pens. The nibs used in calligraphy are called 'broad-edged' nibs. The standard shape is the 'square cut' nib, used mainly by right-handed people. The two other shapes are 'right oblique' nibs, also used by right-handers, and 'left oblique' nibs, which are used by left-handers. Before using nibs for the first time, wash them in warm soapy water to remove the coating that is left by the manufacturing process.

reservoirs

The final component is the reservoir. This is a wedge-shaped device that is attached to the underside of the nib, about 3mm (⅛in) from the tip. If the reservoir is too tight, it will restrict the flow of ink; too loose, and it will fall off. Fill the reservoir using an old brush, rather than dipping it into the ink bottle.

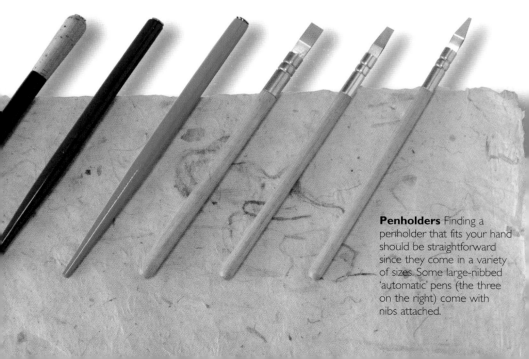

Penholders Finding a penholder that fits your hand should be straightforward since they come in a variety of sizes. Some large-nibbed 'automatic' pens (the three on the right) come with nibs attached.

Nib sizes The size of a nib is often denoted by a number but many more sizes are available for every writing need. Left-handers often use 'left oblique' nibs, which are tapered to the left (shown on the right). Right-handers use 'square cut' nibs and 'right oblique' nibs (shown below and bottom).

SIZE 2 **SIZE 1** **POSTER PEN**

SIZE 4 **SIZE 3** **SIZE 1½** **POSTER PEN**

SIZE 5 **SIZE 4** **SIZE 3** **SIZE 2** **SIZE 0**

SHARPENING NIBS

All nibs lose their edge over time. To keep them sharp, use a sharpening stone. Keep the reservoir on the nib as this will hold it steady.

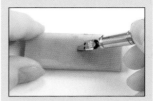

1 Stroke the edge of the nib over the stone from left to right a few times with light, even pressure.

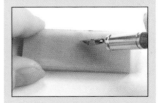

2 Use a light circular motion on the writing edge, then 'tip' the edges.

ATTACHING A RESERVOIR

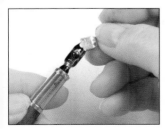
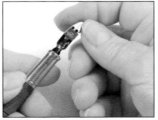
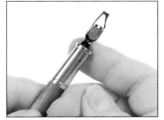

1 Most reservoirs attach to the underside of the nib and are held in place by clips on either side that grip the nib.

2 The reservoir should just slip on, but if it is too tight, loosen the clips very slightly with some pliers (see page 13).

3 Check that the reservoir is about 3mm (⅛in) from the edge of the nib and is not too tight.

Inks and paints

Inks and gouache create colour on the page. Inks are the simplest and are used mostly for creating black writing. Gouache is used for creating colour and often comes in tubes. Different colours can be mixed together to create almost any colour you want.

How well your work turns out is, to a large extent, dependent on the quality of the inks and gouache you use. Always buy better quality materials rather than cheaper ones – the results really are worth it.

inks

The best types to use are black, non-waterproof ink, or Chinese ink. Avoid waterproof and acrylic inks, which are thicker and dry quickly, so are much less forgiving and are harder to work with. Also check the label to see whether the ink is fade-proof. It can be very frustrating to see your work gradually disappear as light falls on it. Avoid waterproof ink, as it contains an agent that interferes with the ink flow and clogs the nib.

The alternative is Chinese stick ink. This is the traditional way of preparing black ink, and it comes as a

solid stick. You will need a slate (or inkstone) and water to grind it down and reconstitute it. This ink produces excellent results, but is usually only used by experienced calligraphers as it is much less convenient than ready-made inks. If you do use stick ink, make sure you thoroughly dry the stick afterwards, otherwise it will crack and splinter.

gouache and watercolours

Although coloured inks are available, gouache and watercolours are best for creating colour on the page. Gouache usually comes in tubes and is opaque, making it ideal for writing on coloured backgrounds where you do not want the colours to show through. A wide variety of colours can be created from just six paints, such as red, blue, green, yellow, black and white. When mixed with a little water, quality gouache will flow easily through the nib.

Watercolours are another favourite among calligraphers and are perfect for background washes, or for writing letters that are more transparent and allow the background to show through.

As for the inks, look for quality, fade-proof materials. The label will usually indicate this.

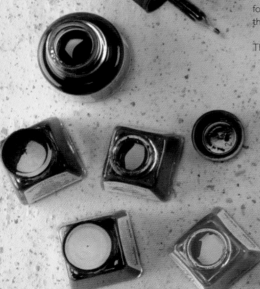

Inks Choose non-waterproof inks for calligraphy – they are easy to use and won't clog the nib.

Gouache Although inks are available in different colours, gouache is the preferred method of applying colour to the page. Gouache typically comes in tubes and, when mixed with a few drops of water, will flow through the nib easily. Colours can also be mixed to produce a wide variety of others.

Brushes In calligraphy, brushes are used for mixing paints and for loading the pen, as well as for painting. An inexpensive synthetic brush, no. 2 size, is good for loading nibs. Use better quality sable brushes for painting.

ADJUSTING A READY-MADE RESERVOIR

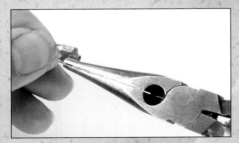

If the reservoir is too tight, use pliers to open the clips; this will help it slip onto the pen point. Also check that the pressure of the reservoir on the back of the nib does not open the slit in the pen point or distort its writing edge. If it does, be careful not to loosen it too much.

Loading nibs

Whichever type of pen you are using, loading the nib with ink or paint correctly will make it easier to produce beautiful flowing letterforms.

MAKING AND FILLING A RESERVOIR

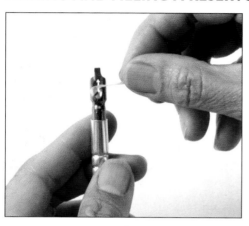

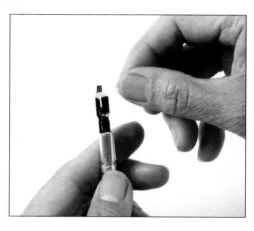

1 Cut a very thin strip of masking tape about 3mm (1/8in) wide and 2.5cm (1in) long. Stick the tape on to the pen point, starting on the top side.

2 Bring the tape around the underside of the pen. Take care that the tape does not stick to the underside but creates a 'pocket' for the ink.

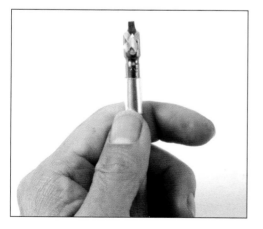

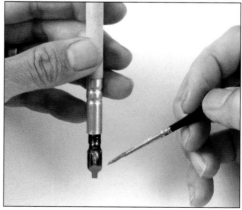

3 Rotate the pen so that the upper side of the nib is facing you and press the tape down firmly on to the nib to make sure it is stuck it on.

4 Using a cheap brush or pipette, fill the reservoir with ink, gouache or watercolour paint and you are ready to start writing.

LOADING TWO COLOURS

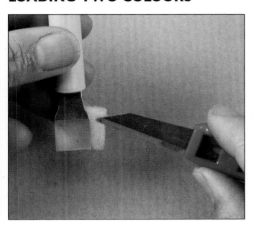

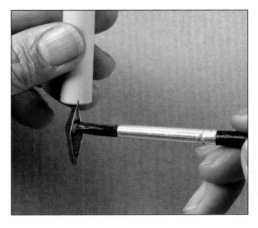

I For an even flow, make a reservoir by cutting a sponge into the same shape as the inside of the broad-edged pen and pushing it into the centre.

2 Use ink or mix paint so that it will flow through the pen. Apply the blue ink or paint using a brush or pipette to fill half of the sponge.

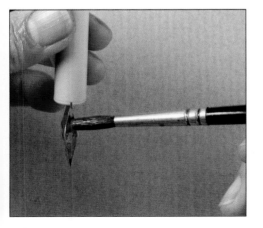

3 Rotate the pen to the other side. Apply the green ink or paint to the other half of the sponge. Saturate the sponge or else the colour will not flow.

4 Make vertical strokes to test the flow of the dual colours. When adding colour, apply the right colour on the correct sponge edge.

Papers

The type of paper you use will have a great impact on the results you can achieve. Each type of paper has been developed for its ability to hold a range of inks and paints and to produce a range of artistic effects.

Use paper that has a smooth, but not shiny, surface. This will enable your nib to move across the page easily without catching in the fibres and creating small spatters of ink. A smooth surface is also ideal for practising your letterforms. Once you are happy with your work, you can move onto heavier, more textured papers. 'Layout' paper (sometimes called 'layout bond' paper) is economical practice paper and is semi-transparent, making it ideal for experimenting with layouts, since it is thin enough to trace from one sheet to another.

Typically, layout paper comes in pads available from any art shop, with sheets weighing around 80gsm. Paper that is heavier than this starts to becomes opaque.

heavy weight papers

While layout paper is excellent, its light weight makes it more suited to practising calligraphy than producing finished artwork. For completed pieces, use heavy weight paper, which comes in a great variety of weights and textures, depending on what you are trying to achieve, the type of nib you are using and the inks and colours you are applying.

The first of these papers is 'drawing' (or 'cartridge') paper. This produces good results and is reasonably priced, but be careful to check that you buy one with a smooth surface.

Watercolour papers come in a variety of surface textures. The smoothest is 'hot-pressed' paper which is ideal for fine writing. 'Cold-pressed' paper has a slightly textured finish and is also called 'NOT' paper. 'Rough' paper is the most heavily textured, but bear in mind that the more textured the surface, the larger the nib you need – it is very difficult to achieve fine writing on very rough paper.

Watercolour paper is not the only textured paper. You will also find smooth (wove), lined (laid) and toothy finishes on a variety of other papers.

choosing the right paper

It sounds obvious to say, but be careful to choose a paper that suits the type of calligraphy you are trying to create. A letter can be written on some good quality, smooth stationer's paper, but a certificate or a piece of art to mount on a wall needs to be made from something more substantial. Also bear in mind any background colour you want to add to your work. If a watercolour wash is applied, you will need a thick paper that does not wrinkle when it dries. A 300gsm paper will work well here. This also holds true when using ink. If lots of ink is applied to a paper that is too thin, 'bleeding' occurs, where the ink blots into the surrounding paper resulting in thick, fuzzy strokes. The key is to experiment and see which combinations of inks, paints and papers work well together.

Alternatively, try some of the many coloured papers that are available. These come in a variety of weights and textures to suit almost all needs, and mean that you do not have to colour your own backgrounds.

Papers Choosing the right paper weight and surface texture is key to getting the results you want from your calligraphy. Papers also come in a wide range of colours so you can experiment with different background effects.

Basic techniques

The basic techniques in calligraphy are very different to those of ordinary writing. You need to learn how to handle a broad-edged nib, how to create consistent letterforms and how to put it all together to create your piece of art.

Learning how to create calligraphy means that you have to reconsider your writing techniques. Whereas a ballpoint pen has a pointed nib, the nibs used in calligraphy are flat and wide. This gives you much more to think about when writing.

holding the pen

The first thing to learn is how to hold the pen. Grip the penholder firmly but comfortably, and make sure it feels right in your hand before you put pen to paper. The main point is that you cannot just pull the pen across the page without thinking as you would with a ballpoint. Your fingers, hand, wrist and arm all have to move to slide the nib across the page. Practise moving your arm and hand across the page, keeping the pen nib at a consistent angle. Also practise pulling the pen down in straight lines and making curved strokes. Your movements need to be slower and more deliberate than normal.

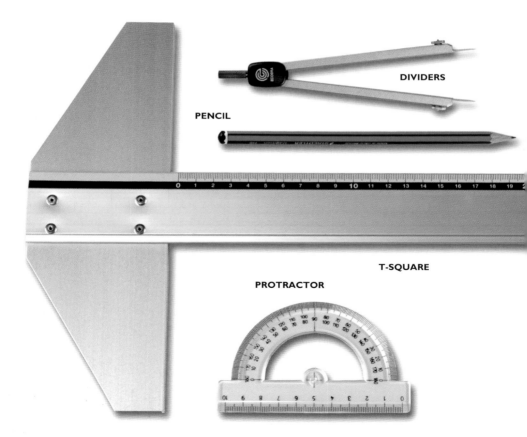

DIVIDERS

PENCIL

T-SQUARE

PROTRACTOR

controlling the nib

The next issue is the amount of pressure to put on the nib. A standard ballpoint is very forgiving – you can write with as much or as little pressure as you want and the ink still comes out to produce legible script. The nib of a calligraphy pen needs to be handled more carefully and the writing edge placed very gently on the page.

As you move the nib over the paper, place light, but even, pressure over the whole of the width of the nib. Practise this a few times without any ink in the reservoir. If you press too hard, you will see the slit in the nib open up, which will stop the smooth flow of ink onto the paper. Pressing too hard also tires your fingers and hand, which will quickly start to feel cramped and uncomfortable.

Stationery Some basic stationery is essential to planning the position of your calligraphy on the page. Without it, your work will not look neat or precise.

ESTABLISHING NIB WIDTHS

The height of the letters is known as the 'x-height' and is measured in nib widths. Draw a line across the page, then build a 'staircase' of nib widths with the pen at 90 degrees.

Alternatively, draw a line across the page, then form a 'ladder' of nib widths leading down from it. The bottom edge of the final nib width is the marker for the baseline.

Basic techniques continued

RULING THE PAPER

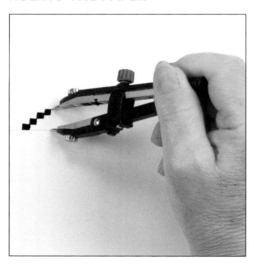

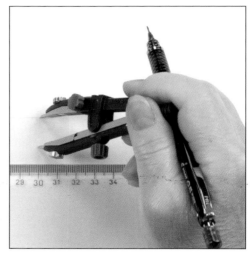

I Create the tramlines that mark the top and bottom of each letter. Use a divider to measure the x-height, placing one point on the line and the other at the top of the staircase.

2 Move the divider to the end of the line and place one point on it. Gently press the other point into the paper to mark where the top line will come.

3 Join the top of the staircase to the point you have pressed into the paper. Your tramlines should be a consistent width apart along their length.

KEEPING TO THE RULES

I Follow the information given at the start of each hand to find out the nib-width heights.

2 Using the same nib-width method, add an extra line above and below the tramlines to mark the height and depth of the ascenders and descenders.

3 The tramlines mark the top and bottom of the body of the lower case letter 'x', the 'x-height'.

Also, if you press too hard on one side, the nib will start to bend and distort, with one side ending up higher than the other. This results in uneven pen strokes. The problem is compounded if you are writing on paper with a rough texture. Instead, try to imagine that the nib is gliding across the page on a thin film of ink, in much the same way that an iceskater glides across the ice on a film of water. Aim to get your strokes as graceful and as fluid as you can.

pen angles

The next stage is to practise holding the nib at the right angle. To start, imagine a horizontal line across the page.

A common nib angle is at 45 degrees to this line, and many hands are written in this way. However, there are others, written at varying angles, such as 15 and 30 degrees. Maintaining a consistent nib angle is essential to producing good work and this is a recurring theme throughout the hands. As you write, you will see that the vertical lines are thick and the diagonals become thinner. This is what gives the letterforms such beauty – there is a perfect balance and distribution between thick and thin strokes. The importance of consistency quickly becomes clear, too.

So try to keep a constant check on the way you are working as you write. Bear in mind that your fingers,

LEFT- OR RIGHT-HANDED?

Whichever hand you use makes no difference to the quality of the work you can produce. However, since the nib has to be held at the same angle for both hands, there are differences in the way a left-hander has to hold the pen compared to a right-hander.

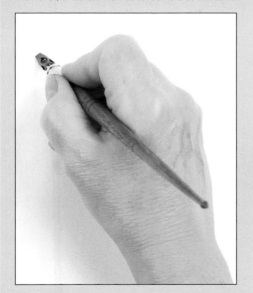

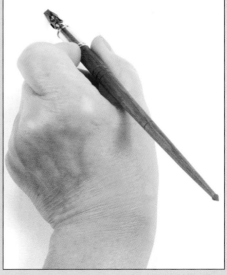

RIGHT-HANDER If you are right-handed, hold the pen between your thumb and first finger, keeping the nib at a diagonal angle. Calligraphy requires a precise and skilful touch, so maintain a light, but comfortable, pressure on the penholder.

LEFT-HANDER If you are left-handed, point your hand to the left, keeping the pen at a diagonal angle. Turn the page slightly to help you with this. Also keep your elbow close to the side of your body to help maintain the right position for your hand.

Basic techniques continued

hand and arm are all involved in creating the letterforms; that your nib pressure needs to be even as you write; and that your pen angle needs to be consistent from letter to letter. This is a lot to remember to start, so do not be put off if you can't get it all right straight away. Calligraphy requires practice and patience, which is what makes it so rewarding.

guidelines and basic strokes

Before you start writing, you need to be sure that your letterforms will look straight on the page. To do this, draw ruled guidelines (tramlines) across the page, like

those found in an exercise book. The distance between the lines is the height of the body of the letter, and is called the 'x-height'. The x-height is measured in nib widths, and is predetermined for all the hands. Strokes that rise above the x-height, such as the vertical upstroke of the letter 'd', are called ascenders, and strokes below the x-height, such as 'g', are called descenders. The heights of the ascenders and descenders are also predetermined and are measured in nib widths. This information, along with nib angles and all the other technical aspects for each letter are given next to the alphabets at the start of each hand.

Then you can begin to put together the basic strokes that form letters. The key to good calligraphy is that each letter should be crisp. Load your pen with a brush and start the letter (each letter is broken down into its component strokes in 'The Hands' chapter). Make a small sideways movement to start. This encourages the ink to flow into the slit in the nib and smoothly flow onto the paper. Make this movement on a piece of scrap paper, or use it to form the 'serif', the small hook or line that starts the letter.

Start with some vertical downstrokes at a variety of angles to see how the line widths differ for each angle, then draw some zig-zags to see how consistent pen angles produce both thick and thin lines. Practise some curves to see how the thickness of the lines change as the pen moves in a circular motion. The letter 'o', which is the basis for all the letters in each hand, demonstrates this well. Also practice taking your pen off the page and replacing it at the top of a previous stroke to see how to make clean, smooth joins between the strokes.

PEN ANGLES

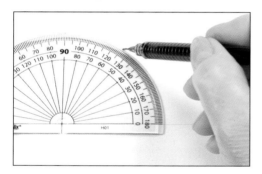

Maintaining a consistent pen angle is important in producing good-quality work. Place a protractor on the baseline and mark off the required angle.

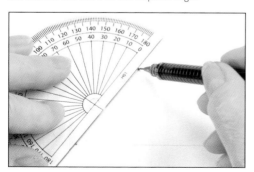

2 Use the edge of the protractor (or a ruler) to draw a line from the mark to the baseline.

3 You now have the correct angle at which to place your nib on the page.

BASIC STROKES

Practise pulling the pen down with a nib angle of zero degrees. This produces the thickest line possible.

Now try the same exercise with a nib angle of 15 degrees. The line starts to get thinner.

Then pull the pen down with a nib angle of 45 degrees.

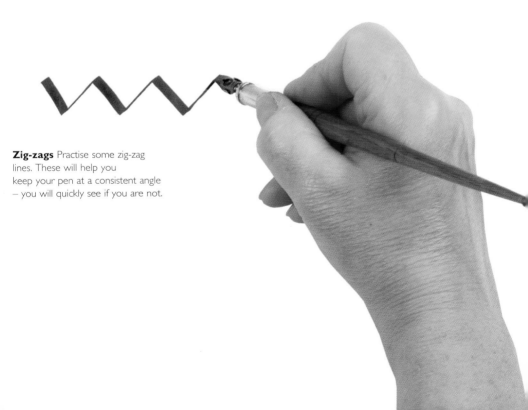

Zig-zags Practise some zig-zag lines. These will help you keep your pen at a consistent angle – you will quickly see if you are not.

Basic techniques continued

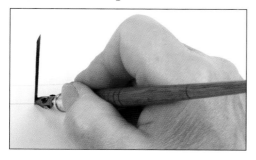

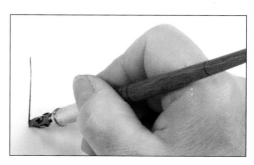

Try drawing a line with the pen at 60 degrees. As the angle becomes sharper, so the line gets thinner.

Try a line with an angle of 90 degrees, so the pen is at right angles to the baseline. This is the thinnest line that is possible.

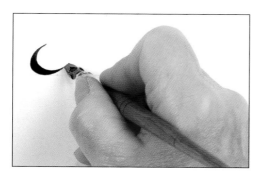

Next, practise some curves with a 30-degree pen angle, such as the first half of the letter 'o', shown here.

Similarly, practise the same stroke in the opposite direction. See how the letter starts with a thin line that gets thicker, then thinner, all in one movement.

Try linking a curve to a vertical line, such as the arch and downstroke from the letter 'n'. The thin line gradually becomes thicker as it curves around.

Finally, try the two curves that make up the letter 's'. The pen angle is consistent, so the thin lines at the top and bottom are parallel, creating a precise letterform.

NAMING THE PARTS OF LETTERS

The component parts of each letter are named to make them easy to describe, and you will come across them in the course of this book. However, these names are not standardised – you may find the same parts described differently elsewhere.

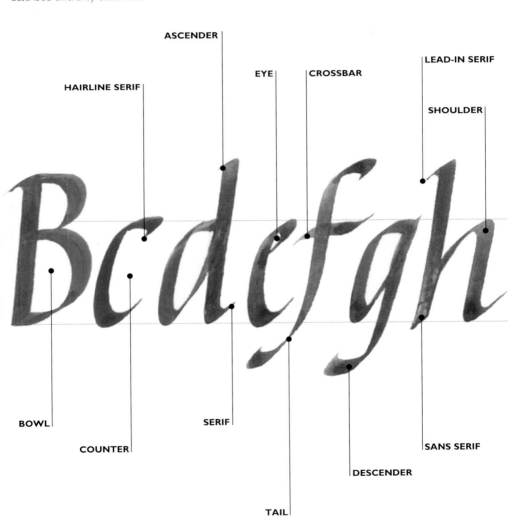

Basic letters

Once you have the feeling of the pen and know how to write basic pen strokes, you can begin to combine the strokes to write letters.

First, determine the height of the lowercase letters (minuscules). To do this, write five horizontal strokes, all stacked on top of each other. To write the letter 'i', hold the pen at a 45-degree angle and make a diagonal upward stroke. This creates a 'serif'. Then, pull the pen downward to create a vertical stroke and finish the letter with another serif at the bottom.

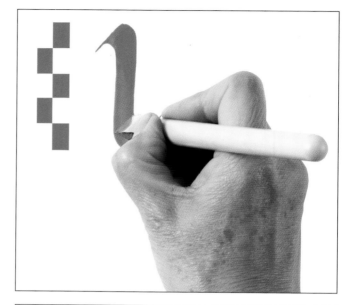

The letter 'b' is a two-stroke letter. Begin the ascender from the top with a vertical stroke, gently pausing before moving the pen downward to the right to make a diagonal line. Stop and lift the pen to start the second stroke from the ascender. Move the pen at a 45-degree angle upward, pause, then move the pen downward diagonally. Use a vertical downward stroke to meet the bottom of the ascender and complete the letter.

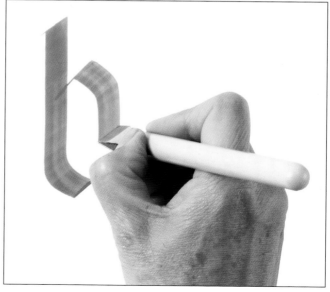

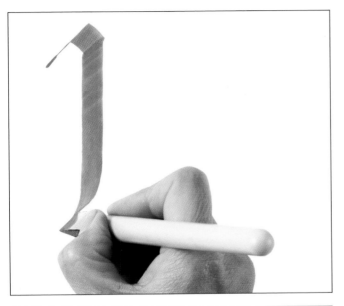

1 This is the first stroke (the descender) of the letter 'p'. Begin with a diagonal stroke upward at 45 degrees. At the top, move the pen diagonally downward to the right to make a very short stroke. Then, bring the pen downward to make a vertical stroke, keeping the pen at a 45-degree angle throughout. At the bottom of the descender, stop and lift the pen.

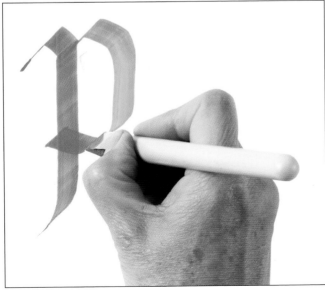

2 To start the second stroke of the letter 'p,' place the pen at the top corner of the vertical stroke. Make a short, upward diagonal line, pause, then make a downward diagonal line to establish the width of the letter. Bring the pen downward to make another vertical stroke and pause. To finish writing the letter, either push the pen to the left or lift the pen and place it just to the left of the first vertical stroke and write the base of the letter.

Basic letters continued

The style of calligraphy shown here is based on the diamond-shaped letter 'o'. Begin this two-stroke letter by moving the pen downward to the left toward the midway point of the letter height. Then, pull the pen back in toward the centre of the letter at the base and finish with a thin, diagonal upward stroke. The second stroke begins again at the top with a thick, diagonal downward stroke to the right to about the midway point of the letter height. Then, pull the pen downward to meet the bottom of the letter.

The letter 'x' is written with two strokes. The first is from top left to bottom right. It begins with a thin, diagonal, upward stroke to the right to make a serif, then a strong, thick, downward diagonal stroke, again to the right. The second stroke is usually made diagonally downward from top right to bottom left. Bring the pen downward at a steeper angle than that used on the first stroke. This produces a strong line.

WRITING A DECORATIVE CAPITAL

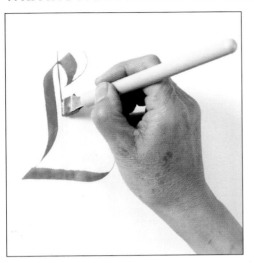

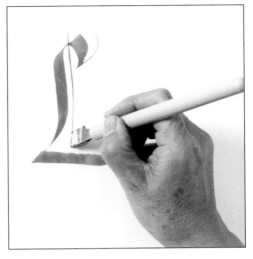

First, write the capital letter 'L'. To make the thin vertical line, rotate the pen so that it is vertical as shown, then pull it downward in a smooth stroke.

2 The vertical line has a slight curve at the bottom to mimic the vertical stroke of the capital letter. Move your arm to help you write the line more easily.

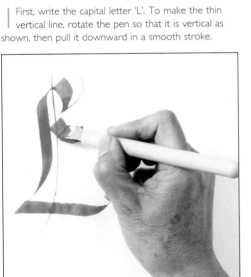

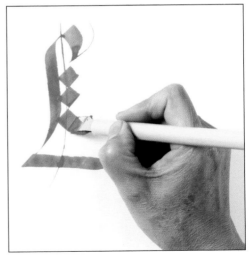

3 To make the diamond 'dot', position the pen so that the left corner of the writing edge touches the vertical stroke of the 'L'. Pull the pen diagonally downward to the right.

4 For the next dot, slide the pen downward to the left at 45 degrees until the left edge of the pen point touches the 'L'. Repeat steps 3 and 4 to create a sequence of dots.

The hands

The different writing styles are called 'hands', and in this chapter you will learn how to create six of the best.

Each hand is divided into several sections. First, a full alphabet is provided for your reference, along with essential technical information, such as nib angles and nib widths. Since many letters share the same characteristics, each hand is then split into 'groups' of letters. The main letters from each group are illustrated in detail, along with stroke reminders to show how to create the rest. The final section in each hand demonstrates how to put the letters together in a line, showing a selection of letters all correctly spaced.

Foundational

Formulated by Edward Johnston, the Foundational hand is based on a circle and a vertical straight line. Johnston based his hand on a script from the 10th century Ramsey Psalter.

abcdefghijklm
nopqrstuvwxyz
ABCDEFGH
IJKLMNOPQ
RSTUVWXYZ
1234567890

LOWER CASE

X-HEIGHT 4 nib widths
PEN ANGLE 30 degrees; 45 degrees for thick strokes of v, w, x and y
LETTER SLOPE Upright
FORM Circular O
ASCENDERS 2½–3 nib widths
DESCENDERS 2½–3 nib widths
SERIF STYLE Circular
SPACING Equal area of spacing between letters

CAPITALS

X-HEIGHT 7 nib widths
PEN ANGLE 30 degrees; 45 degrees for thick strokes of A, V, W, X, Y; 60 degrees for first stroke of M and first and last stroke of N; 0 degrees for Z diagonal
LETTER SLOPE Upright
FORM Circular O
SERIF STYLE Circular
SPACING Letter: Visually equal areas, approx. ⅔-width of N counter. Word: Slightly less than O width

circular letters – o, e and p

The letter 'o' is circular in the Foundational hand. This circular shape therefore also forms the basis for the letters 'b', 'c', 'd', 'e', 'g', 'p', and 'q'.

Stroke reminder

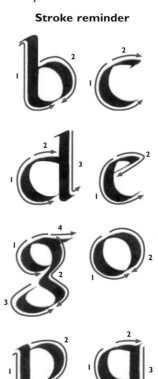

1 | Start the letter with the pen nib at 30 degrees. Pull the pen round smoothly for the first half of the stroke.

2 | Complete the letter with a mirror image stroke. The final letter should be circular with smooth joins.

1 | The first stroke is like the 'o', but in this case, slightly straighten the back of the letter so it does not appear to be falling over.

2 | Take your pen off the paper and complete the top of the letter. The top joins just above half way.

1 | Start the vertical downstroke with a serif.

2 | Keep the pen top flat and pull it around smoothly to form the bowl, reflecting the curve of the 'o'.

3 | The bottom of the bowl is a flattened curve and begins halfway down the stem.

diagonal letters – k, v and x

The diagonal letters are 'k', 'v', 'w', 'x', 'y' and 'z'. Remember that the pen angle changes for the thick strokes of the letters 'v', 'w', 'x' and 'y' and all the strokes of 'z'.

Begin three nib widths above the x-height and start with a serif. Then pull the pen down vertically.

Just touch the first downstroke with the nib. Create the diagonals at 90 degrees to each other.

Stroke reminder

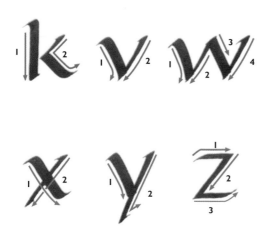

Make the diagonal strokes straight. Only the serifs on entry and exit are curved.

| Steepen the pen angle to 45 degrees to make the first stroke. It is important to keep the strokes symmetrically upright.

2 Make the second stroke less steep. The strokes should look upright to the eye.

| As with the letter 'v', steepen the pen angle to 45 degrees for the first thick stroke.

2 The second, slightly flatter, stroke should cross the first stroke just above the halfway point.

ungrouped letters – f, s and j

The ungrouped letters in the Foundational hand are 'f', 'j' and 's'. However, they all have related curves.

Pull the pen down from three nib widths above x-height to the baseline, ending with a small serif.

2 Working from the top of the first stroke, form the slightly flattened top of the letter.

Stroke reminder

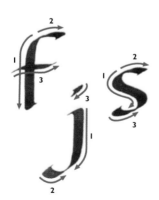

3 To complete the letter, place the top of the crossbar on the line.

| Pull the pen straight down until the ascending stroke finishes 2½–3 nib widths below the baseline. | Join the curved tail smoothly to the bottom of the downstroke. Add a dot, which relates to the serifs. |

The first stroke of the letter 's' is fairly horizontal. Both the top and bottom counter curves are flattened.

Make sure the top bowl is slightly smaller than the bottom one, and the letter should align vertically at the front.

clockwise arches – a, h and m

The letters in this group are 'a', 'h', 'm', 'n' and 'r'. The letter 'i' is also included. The strong branching arches that form the tops of the letters are emphasized in this hand.

1 The first stroke starts with a lead-in serif. The bottom serif ends the downstroke and is smaller.

2 Start within the downstroke (the stem) and make a strong circular arch, as in the letter 'a'.

3 Repeat for the second arch. Each half of the letter should be of equal width. Finish with a slightly larger serif than you started with.

Stroke reminder

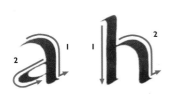

1 The top curve of the 'a' relates to the 'o' – a circular arch with a vertical downstroke and serif.

2 Start the bowl below half way. Bring the pen down to the baseline, reflecting the curve of the 'o'.

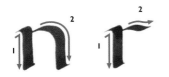

1 The ascender starts with a serif and is three nib widths above x-height. Pull the pen down to the baseline.

2 The arch of the 'h' reflects the same shape as the 'o'. Pull the pen down and add a small serif to finish the letter.

anti-clockwise arches – t, l and u

There are only three letters in this group – 'l', 't' and 'u'. In this case, the base of the arch follows the curve and proportion of the 'o'.

1 Start the stroke slightly above the top line, and with no serif. Pull the pen down and around to create a circular bowl.

2 The top of the crossbar sits immediately below the top line, just touching it. Keep your pen angle consistent.

1 Start the ascending stroke with a serif. Pull the pen down vertically and finish with a curved base.

Stroke reminder

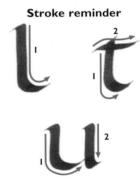

1 Start with a small serif and pull the pen down into an arch. The base of the 'u' relates to the arch of the 'n'.

2 The second downstroke mirrors the first but, in this case, it ends with a serif.

putting it all together

Mxaqtwj

Roman capitals

Based on ancient Roman carved stone inscriptions, Roman capitals have elegant proportions constructed on the basis of the square and a circle within the square.

circular letters – O

'O' and 'Q' are circular letters. 'C', 'D' and 'G' are ⅞ width of a square containing the circle.

Stroke reminder

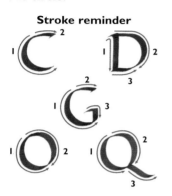

1 Start with the nib sitting just under the line. The top and bottom arcs should both cut the line.

2 Mirror the same stroke in the opposite direction to create a smooth, circular shape.

three-quarter width letters – A

The three-quarter width letters are 'A', 'H', 'N', 'T', 'U', 'V', 'X', 'Y' and 'Z'.

1 Steepen the pen angle to 45 degrees on the first downstroke.

2 Keep the same angle for the second stroke, finish with a serif.

3 Complete the letter with a crossbar, slightly below half way.

Stroke reminder

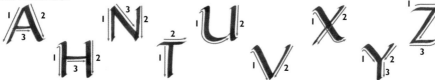

wide letters – W

The wide letters are 'M', which is the width of a square, and 'W', which is made from two 'V's.

Stroke reminder

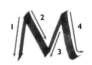

1 Make the first stroke with your pen at 45 degrees, starting with a lead-in serif. On the second stroke, pull the pen down, keeping a consistent angle, to join the bottom of the first stroke.

2 Repeat the first downstroke, making sure the angle of the line is consistent. The last downstroke starts with a small serif. This is a very wide letter – keep it upright.

half–width letters – P

The half-width letters are 'B', 'E', 'F', 'K', 'L', 'P', 'R' and 'S'.

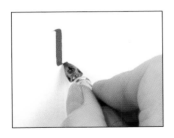

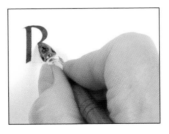

1 Start the stroke with a serif, then pull the pen down vertically to the line. Keep your pen angle at 30 degrees.

2 The bowl of the letter should be a smooth circular shape. Stop before reaching the first downstroke.

3 The base of the bowl is finished with a straight stroke, beginning at half way and curving smoothly to join the bowl.

Stroke reminder

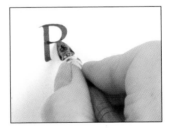

Uncial

Uncials were developed from Roman capitals between the fourth and eighth centuries. The strong, round, lower case letterforms were widely used as formal book hands.

ABCDE
FCHIJKLMN
OPQRSTUV
WXYZ
1234567890

LOWER CASE

X-HEIGHT 4 nib widths
PEN ANGLE 15-25 degrees
LETTER SLOPE Upright
FORM O slightly wider than a circle, round arches, upright alphabet

ASCENDERS 2 nib widths
DESCENDERS 2 nib widths
SERIF STYLE Round
SPACING Visually equal areas of spacing. NI distance is ⅔-width of N counter

round letters – o, g and e

Based on 'o', which is slightly wider than a circle, this group consists of 'c', 'd', 'e', 'g,' 'o', 'p' and 'q'.

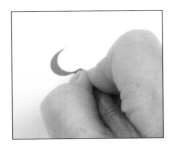

Stroke reminder

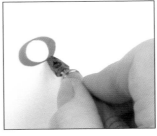

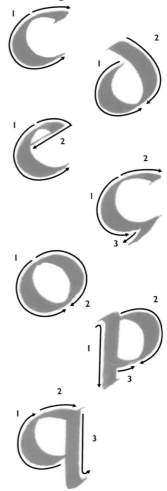

| With a pen angle of 25 degrees, pull the pen round for the first curve. 'O' is wider than a circle.

2 Mirror the first stroke, this time working clockwise. The letter should be rounded with neat joins.

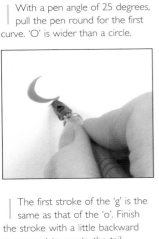

| The first stroke of the 'g' is the same as that of the 'o'. Finish the stroke with a little backward movement to create the tail.

2 Add a slightly flattened curved stroke to the top of the letter.

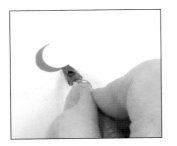

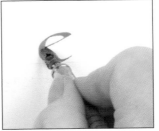

| The first stroke is the same as the letter 'o'. Make sure it is smoothly rounded.

2 Add a flattened curve to the top, then form the counter, which touches the bowl above half way.

straight letters – i, j, l and f

The straight letters are 'f', 'i', 'j', 'l' and 't'.

Start with a small, rounded serif with the pen at 25 degrees. Pull the pen straight down, finishing with a serif.

Repeat the serif and downstroke of the 'i'. To complete the letter, pull the pen to the left and taper off the tail.

Stroke reminder

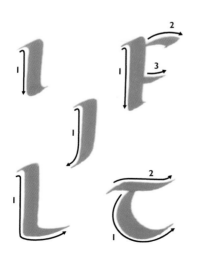

Start the ascender with a serif. Pull the pen down, then straight across, tapering up slightly to the right.

1 The first stroke descends below the baseline. The top is slightly curved and springs from the downstroke. The curve relates to the arched letters.

2 The third stroke sits above the baseline, creating a generous space between the arms.

arched letters – h

There are only three arched letters – 'h', 'm' and 'u'.

Stroke reminder

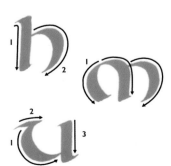

1 Begin the downstroke two nib widths above the line. Pull the pen straight down and finish with a serif.

2 The arch springs from inside the downstroke and is smooth and round. It extends slightly below the line.

diagonal letters – k and n

The diagonal letters are 'a', 'k', 'n', 'v', 'w', 'x', 'y' and 'z'.

The downstroke is a vertical line, beginning with a serif at the top.

2 Keep the diagonals at 45 degrees to the downstroke and 90 degrees to each other. The second stroke just touches the downstroke.

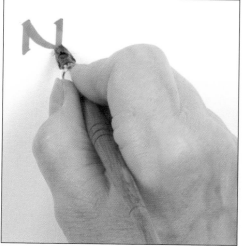

Start with two parallel downstrokes. The second one tapers slightly to the left.

2 Join the two downstrokes with a diagonal, which curves slightly from top to bottom.

Stroke reminder

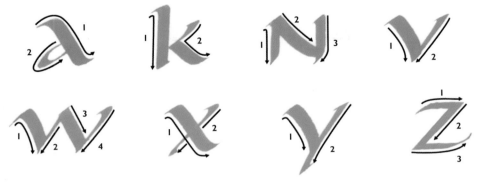

small-bowl letters – b

The three small-bowl letters are 'b', 'r' and 's'.

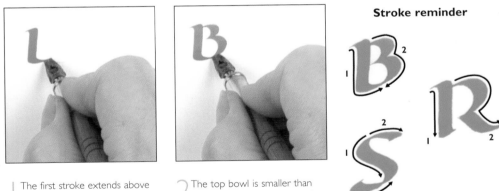

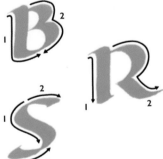

1 The first stroke extends above the line. Pull the pen down, then to the right, to form the base of the letter.

2 The top bowl is smaller than the bottom one. The second stroke is left open – it does not touch the downstroke.

putting it all together

mxaqtw

Gothic

Gothic blackletter was developed between the 12th and 15th centuries. Rounder scripts were gradually compressed and angularized to produce bold letterforms.

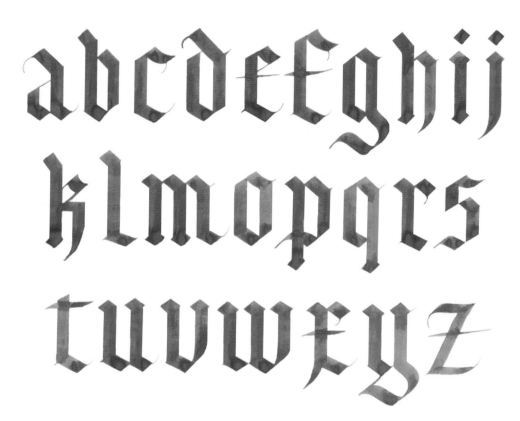

X-HEIGHT 5 nib widths	**ASCENDERS** 2 nib widths
PEN ANGLE 45 degrees	**DESCENDERS** 2 nib widths
LETTER SLOPE Upright	**SERIF STYLE** Angular
FORM Parrallelogram O	**SPACING** Equal spacing between letters

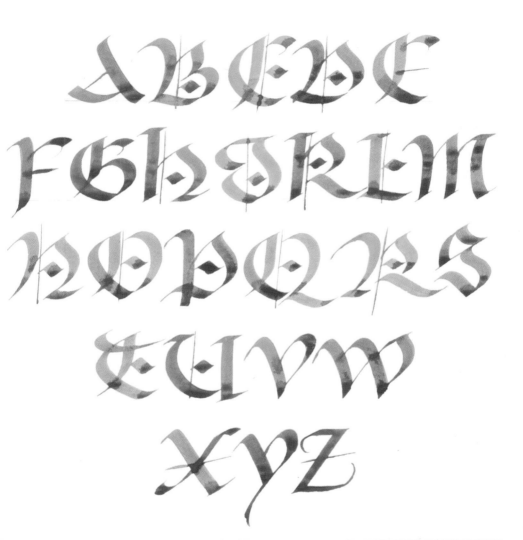

CAPITALS

X-HEIGHT 6 nib widths
PEN ANGLE 45 degrees
LETTER SLOPE Upright
FORM Circular and wide

ASCENDERS 1-2 nib widths
DESCENDERS 1-2 nib widths
SERIF STYLE Hairlines and slab serifs
SPACING Equal spacing between letters

round letters – o, e, and q

The round letters are based on the 'o'. Also in this group are 'a', 'c', 'e', 'g', 'q' and 't'.

1 Starting from slightly below the top line, draw a downstroke that stops just above the baseline.

2 Mirror the first downstroke to complete the letter, adding a small hairline 'ear' on the shoulder.

1 Start the downstroke below the top line. Then add the 'foot' with a hairline serif. Add the eye in one movement, placing it above half way.

2 To finish, add a crossbar using a pen angle of zero degrees.

1 Starting from just below the top line, draw a downstroke that finishes just above the baseline. Add the foot.

2 Add the second downstroke as for the 'o', but continue it below the baseline, finishing with a diamond serif.

Stroke reminder

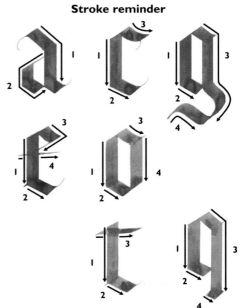

3 Add a hairline ear to the shoulder of the letter using the edge of the pen.

straight strokes with an arch – k and b

These letters have a vertical downstroke with an arch. They are 'b', 'h', 'k', 'm', 'n', 'p' and 'r'.

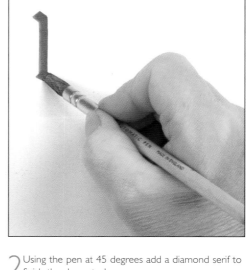

1 Start the ascender with a serif then pull the pen downwards to the baseline.

2 Using the pen at 45 degrees add a diamond serif to finish the downstroke.

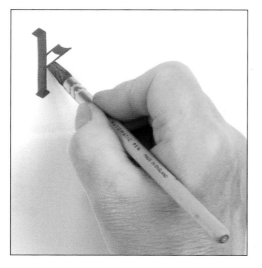

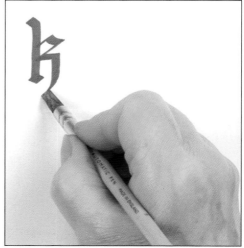

3 Form the counter by keeping the pen angle at 45 degrees. Notice the slight curve in the thick edge.

4 With the pen at the same angle, pull it to the right then downwards. Taper slightly to the left to achieve a softer tail.

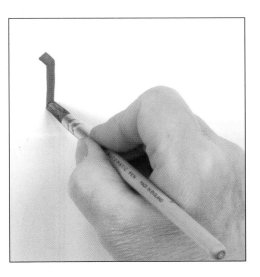

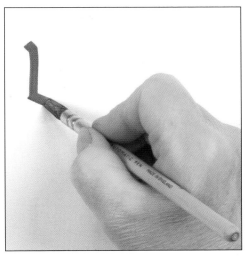

| Start the ascender with a serif, pulling the pen from left to right. Stop the downstroke above the baseline. | Make a long foot for the base of the bowl, stopping on the baseline. |

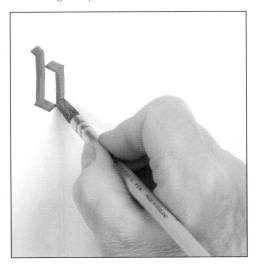

3 Starting from above half letter height, complete the bowl by pulling the pen right and down at 45 degrees. This should relate to the 'o'.

Stroke reminder

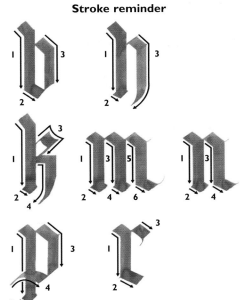

straight-stroke letters – i

This group is based around a vertical downstroke. The letters are 'f', 'i', 'j' and 'l'.

Stroke reminder

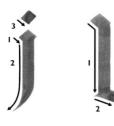

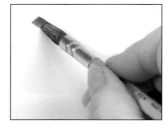

| Start the letter with a 45-degree pen angle to make a diamond serif.

2 Starting in the centre of the serif and pull the pen straight down to just above the baseline.

3 Add another diamond serif to finish the downstroke, again at 45 degrees.

4 Finish the letter by adding a diamond-shaped dot at the same angle as the serifs.

letters based on 'u' – v

The letter 'u' forms the basis for the group comprised of 'u', 'v', 'w' and 'y'.

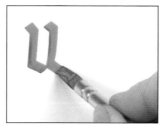

Stroke reminder

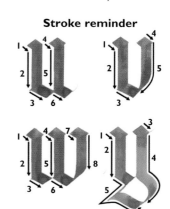

| Start with a serif then add a downward stroke almost to the baseline. End the stroke with an elongated serif to form the long foot.

2 Repeat the downstroke, bringing the pen down to touch the edge of the foot of the first downstroke.

exceptions – s

Some letters belong to no particular group. They are 's', 'x' and 'z'.

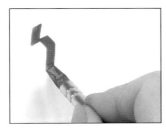

Stroke reminder

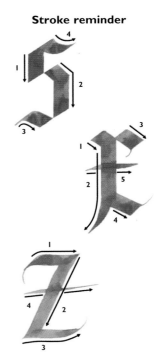

1 Start the stroke on the first 'curve' of the 's', just below the top line.

2 Push the pen diagonally upwards, followed by two downstrokes.

3 Draw the bottom stroke, finishing just above the baseline. Work from the left to add the bottom curved stroke.

4 The top of the letter is also curved. Work from left to right to draw this. Make sure you align the letter at the front.

putting it all together

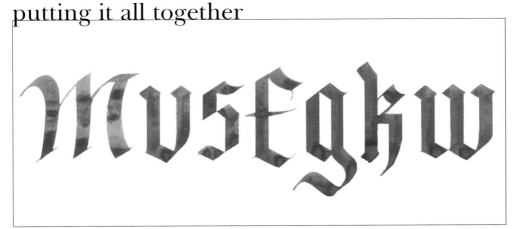

Gothic capitals

The capital letters in the Gothic hand are also known as 'majuscules'. The letters have more strokes than the lower case letters (the 'minuscules'), which produces a decorative script.

rounded letters – Q and E

The rounded letters are based on the 'O' and are 'C', 'E', 'G', 'O', 'Q' and 'T'.

1 Make a wide, generous arc for the first stroke. Add a second stroke from the top, tapering to the left.

2 Add another wider, rounded arc. This stroke is left open – it does not touch the first arc.

3 Add a long tail, which continues the line of the first arc, then tapers upwards.

4 To finish the letter, add a vertical hairline and then a diamond that touches it, both in the middle of the bowl.

Stroke reminder

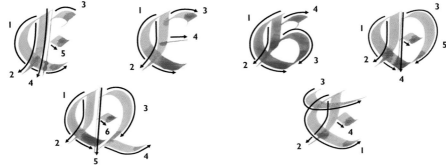

1 | As with the 'Q', make a wide, generous arc to complete the first stroke.

2 Starting from the top, pull the pen straight down, then taper to the left just before you cross the first arc.

3 The top stroke is curved and the crossbar is straight. Both extend beyond the first arc.

straight strokes with an arch – H

The letters in this group are 'F', 'H', 'K' and 'L'.

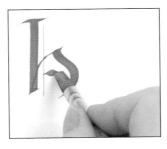

Stroke reminder

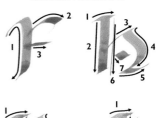

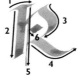

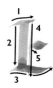

1 | Start with a serif and from the mid-point, pull the pen down to the baseline.

2 Draw a hairline arch, add a wide curve to just below the baseline. Finish the letter by adding a vertical hairline and a touching diamond.

diagonal letters – W

The diagonal letters are 'A', 'V', 'W', 'X', 'Y' and 'Z'.

Stroke reminder

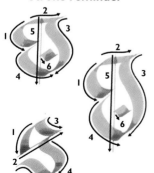

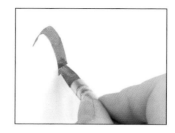

1 With the pen at 45 degrees, sweep it up then pull it down in a slight curve to the baseline.

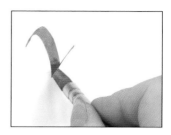

2 Add the second thin stroke, starting below the top line.

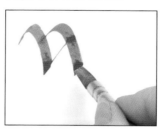

3 Repeat the first stroke so that it just touches the top of the second stroke on the way down.

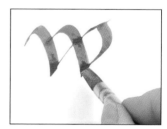

4 Without stopping, push the pen up then pull it down in a wide arc to the baseline.

variants – S

The variants on the letterforms are 'I', 'J' and 'S'.

Stroke reminder

1 Form the top bowl by making a short curved stroke from the top line, then a wider one. Join the two with a hairline stroke.

2 Next add a wide curve to form the first part of the tail. Finish the tail with a long curve. Then join this second half of the letter neatly to the first half.

combinations – B

The combination letters are 'B', 'D', 'M', 'N', 'P', 'R' and 'U'.

1 Sweep the pen around in a generous arc to the baseline. Make the baseline stroke.

2 Work upwards then curve the pen down, tapering inwards slightly.

3 Then sweep the pen round in a wide arc to complete the bottom bowl.

4 Add a hairline extending above and below the x-height and a diamond that just touches the hairline.

Stroke reminder

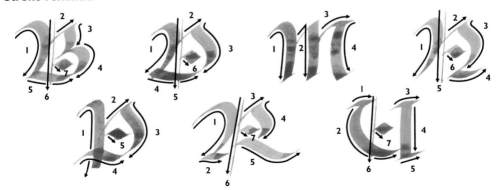

Italic

Italic is a flowing, rhythmical script developed during the Renaissance. It is a versatile, forward-sloping script that uses few pen lifts.

LOWER CASE

X-HEIGHT 5 nib widths
PEN ANGLE 45 degrees
LETTER SLOPE 5-10 degrees
FORM Oval O

ASCENDERS 3-4 nib widths
DESCENDERS 3-4 nib widths
SERIF STYLE Oval
SPACING Equal spacing between letters. NI distance is almost the width of an N counter

ABCDE
FGHIJKLM
NOPQRS
TUVW
XYZ

CAPITALS

X-HEIGHT 8 nib widths
PEN ANGLE 45 degrees
LETTER SLOPE 5-10 degrees
FORM Oval O

ASCENDERS 3-4 nib widths
DESCENDERS 3-4 nib widths
SERIF STYLE Oval
SPACING Equal spacing between letters. N 1 distance is almost the width of an N counter

oval letters – o, c and e

The oval letters are based on the 'o'. The other letters in this group are 'c' and 'e'.

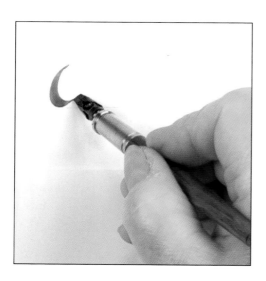

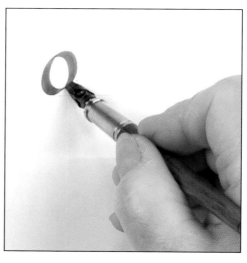

I Start the first stroke with the nib at 45 degrees. The sides of the letter should be fairly flat curves.

2 Mirror the same stroke on the other side, working clockwise and keeping the joins neat.

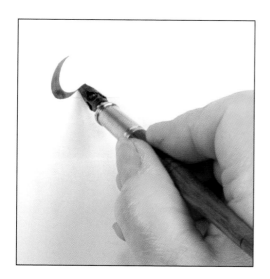

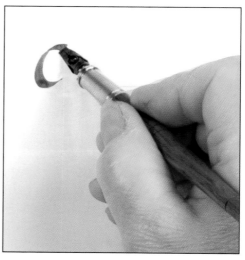

I The first stroke of the 'c' is the same as the first stroke of the 'o', with a flattened back.

2 Add a stroke to form the top of the letter, which is almost flat.

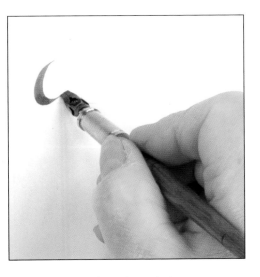 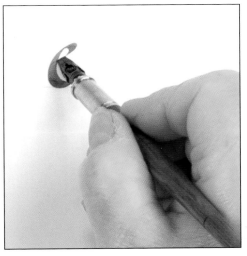

1 The first stroke of the 'e' starts in the same way as the 'o' and the 'c', with the pen at 45 degrees.

2 Working from the top, add the eye of the letter with a small, smooth loop. Keep the bowl above half way.

Stroke reminder

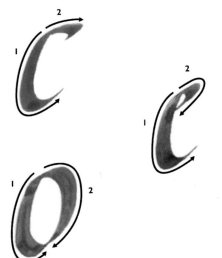

triangular letters – g and a

The letters in the triangular group are 'a', 'd', 'g' and 'q'.

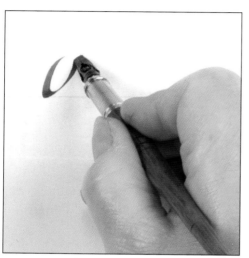

1 The first stroke is a subtle curve followed by a vertical downstroke. The upstroke is a mirror image.

2 Add the top of the letter, which should be a flattened curve, starting at the top of the first stroke.

3 Pull the pen down at a slight angle to form the descender. Taper the stroke to the left.

4 Working from left to right, finish the tail, starting with a serif and joining it to touch the end of the previous stroke.

1 The first stroke of the letter is the same as the letter 'g', with a subtle curve, downstroke and upstroke performed in one smooth action.

2 Add in the top of the letter, which should be a flattened curve. Start at the top of the first stroke.

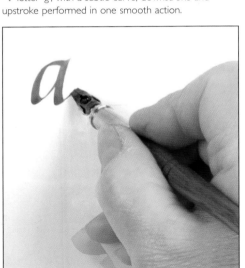

Stroke reminder

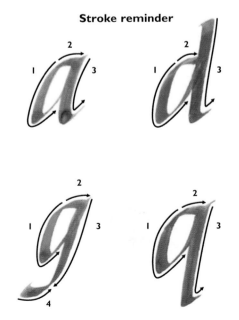

3 Add the downstroke pulling the pen smoothly to the baseline, followed by a short upstroke to create a serif to finish the letter.

clockwise arches – h, m and b

The clockwise arches are 'b', 'h', 'i', 'k', 'm', 'n', 'p' and 'r'.

1 Start the downstroke with an oval serif, then smoothly draw the pen down to the baseline.

2 Keep your pen on the paper as you form the springing arch, then pull the pen downwards. Finish with a serif.

1 Start the first downstroke with a serif. Spring the arch upwards then pull the pen down parallel to the first stroke.

2 In the same movement, spring the second arch to look the same as the first. Finish with a serif.

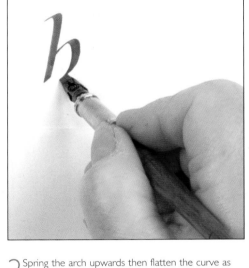

I Start the downstroke with an oval serif. Pull the pen down to the baseline.

2 Spring the arch upwards then flatten the curve as you bring the pen down. Relate the width of the arch and curve to the 'n'.

Stroke reminder

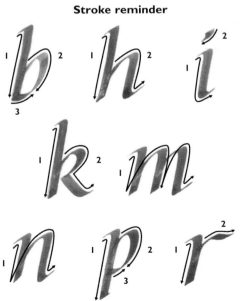

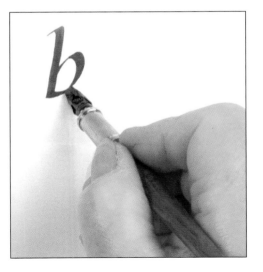

3 Working from the bottom of the first downstroke, complete the bowl with a follow-through curve.

related tops and base curves – f

The three letters in this group are 'f', 'j' and 's'.

I Start the downstroke with the pen at 45 degrees. Pull the pen down smoothly to form a slight curve.

2 Working from left to right, start with a serif then join the tail to the end of the downstroke.

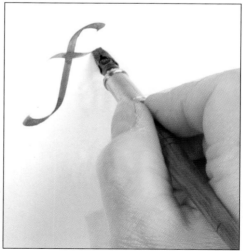

3 Create the top counter, making a spacious, flowing join. Make sure that your pen angle is consistent.

4 Finish the letter with the crossbar that comes on, or slightly below, the line.

Stroke reminder

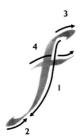

diagonal letters – y and x

The last five letters in the alphabet – 'v', 'w', 'x', 'y' and 'z' – make up this group.

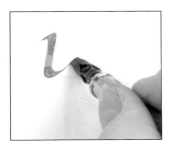

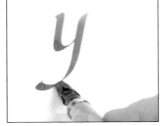

Stroke reminder

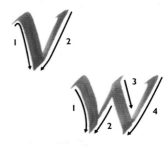

| Start the stroke with a serif, pull the pen downwards then curve upwards, all in one movement.

2 The next stroke is parallel to the first, and tapers below the baseline. Finish the tail with a serif and a flattened curve.

| With the pen at 45 degrees, start with a small serif then pull down, finishing with another small serif.

2 The second, slightly flatter, stroke should cross the first stroke just above the half-way point.

anti-clockwise arches – u

There are only three anti-clockwise arches – 'l', 't' and 'u'.

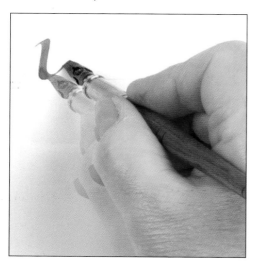

| Start the stroke with a serif, pull the pen downwards then curve upwards, all in one movement.

2 Start the second stroke at the top of the line. Keep the stroke parallel to the first. Finish with a serif.

Stroke reminder

l *t* *u*

putting it all together

Mxaqtwj

Italic capitals

Italic capitals are a compressed version of Roman capitals with a forward slope. They are based on an oval of the same shape found in the italic lower case (minuscule) letters.

rectangular letters – H

These letters are three-quarters of the width of the oval and are 'A', 'H', 'N', 'T', 'U' and 'V'.

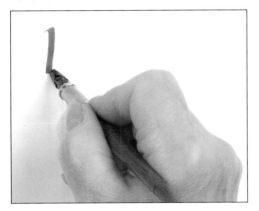

1 Start the letter with a serif, followed by a downstroke.

2 Repeat the same stroke for the second downstroke. Finish this one with a small serif.

3 Add a crossbar just above half way to complete the letter.

Stroke reminder

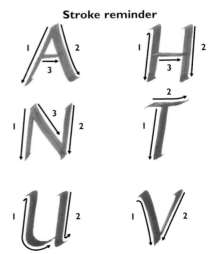

oval letters – D

The oval letters are based on the 'O' and also include 'C', 'D,' 'G' and 'Q'.

Stroke reminder

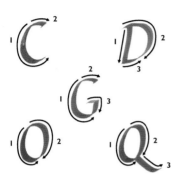

1 Make the downstroke. Then starting at the top of the downstroke, pull the pen round in a wide arc.

2 Finish the bowl with a flattened curve. The letter should be the same width as 'C' and 'G'.

wide letters – W

There are only two wide letters – 'M' and 'W'.

Stroke reminder

1 Start with a serif and a slightly curved downstroke to the baseline. Make the second stroke from the top down.

2 Repeat the first two strokes to form the second half of the letter. Keep the spacing consistent.

half-width letters – E

'b', 'e', 'f', 'k', 'l', 'p', 'r' and 's' are the letters in this group. 'I' and 'J' are also included.

1 | Starting with a serif, make the first downstroke, draw the pen smoothly to the baseline.

2 Then add the top arm, keeping your pen angle at 45 degrees. The arm touches the downstroke.

3 Add the middle arm, just above half way. It is slightly shorter than the top one.

4 Add the base arm. This should be slightly longer than the top arm, and tapers upwards slightly.

Stroke reminder

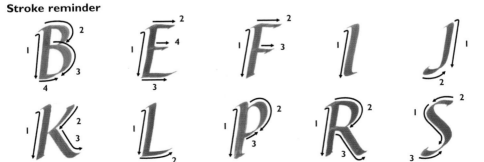

Sharpened italic

Sharpened italic is one of the many variations on the classic italic hand. The main features of this hand are the triangular arches and the sharpened serifs.

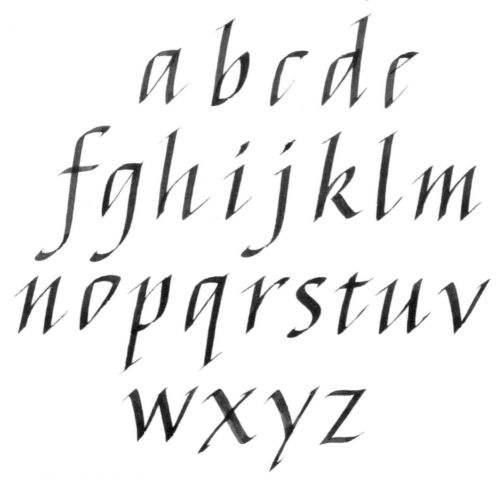

LOWER CASE

X-HEIGHT 5 nib widths
PEN ANGLE 45 degrees
LETTER SLOPE 12-70 degrees
FORM Triangular O

ASCENDERS 3-4 nib widths
DESCENDERS 3-4 nib widths
SERIF STYLE Sharpened
SPACING Equal spacing between letters. Nl distance is almost the width of an N counter

triangular letters – g, o and a

The triangular letters are based on 'o'. The other letters in this group are 'a', 'c', 'd', 'e', 'g' and 'q'.

1 As for the 'o', make a downstroke and in one movement, move the pen upwards.

2 Take the pen off the paper and place it at the top of the first stroke. Pull the pen across the paper.

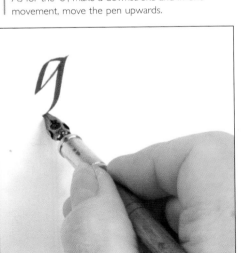

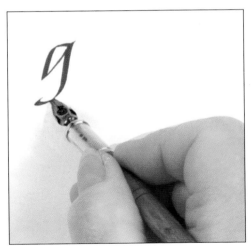

3 Add a small hairline 'ear' to the shoulder of the letter, then pull the pen downwards, tapering below the baseline.

4 Finish the letter with a serif followed by a flattened curve to join up with the previous stroke.

triangular letters – g, o and a continued

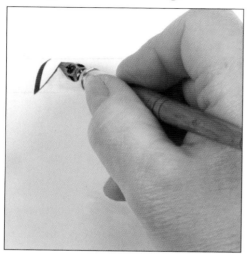

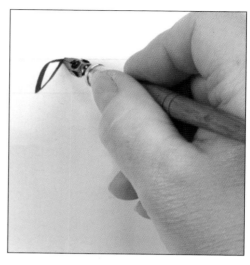

1 With your pen at 45 degrees, pull it down. Without lifting the nib, continue in an upward movement.

2 Take the pen off the paper and replace it accurately where you started the stroke, keeping the nib at 45 degrees. Pull the pen across the paper to meet the top of the upstroke.

Stroke reminder

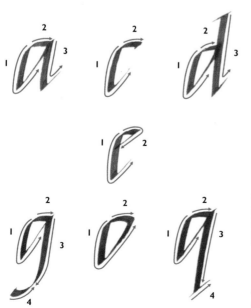

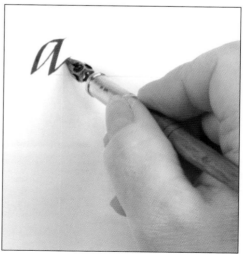

The first three strokes for the 'a' are the same as for the 'o'. To finish the 'a', add a downstroke parallel to the first stroke, then add a final upstroke, keeping the upward turn sharp.

clockwise arches – m and k

There are four clockwise arches – 'b', 'k', 'm' and 'n'.

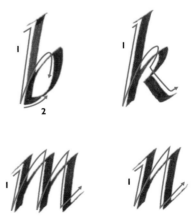

1 | Make a sharpened serif then quickly pull the pen downwards. Spring upwards for the angular arch, the pen should not leave the paper.

2 Pull the pen straight down to the baseline for the second downstroke. Keep the turn sharp.

Stroke reminder

3 Repeat the angular arch and downstroke to form the second half of the letter. Keeping the pen on the paper, finish the letter by adding a sharpened serif.

clockwise arches continued

1 Create a long ascender, starting with a serif, pull the pen down. Draw a springing arch and finish the bowl and tail in one movement.

2 Keep the bowl sharpened and finish with a serif. Notice that the bowl is open and does not touch the downstroke.

anti-clockwise arches – t and u

The anti-clockwise arches are 'l', 't' and 'u'.

Stroke reminder

1 Start with an upward stroke for the sharpened serif. The downstroke ends with an upward movement.

2 Add the crossbar, placing it on the line. Keep the pen angle consistent.

1 Make a serif, then pull the pen down. Push the pen upwards to create the second stroke.

2 The final stroke is parallel to the first. Make sure your pen angle is 45 degrees.

related tops and base curves – s

There are three letters in this group – 'f', 'j' and 's'.

Stroke reminder

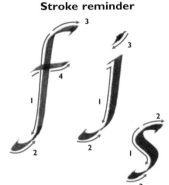

1 Make the centre stroke first, keeping it angular. The curves of the stroke are flattened.

2 Go back to the top and add the top of the letter, which is almost flat. Then add the bottom stroke.

diagonal letters – x

The last five letters of the alphabet – 'v', 'w', 'x', 'y' and 'z' – make up this group.

Stroke reminder

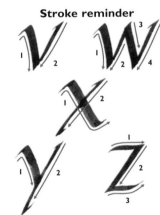

1 Start with a serif, then pull the pen down to make the first diagonal stroke.

2 The second diagonal crosses the first just above half way.

putting it all together

pniyslcrax

Copperplate

All copperplate scripts are created using a pointed nib. Different line weights are created by varying the pressure on the nib rather than by altering the pen angle.

a b c d e f

g h i j k l m n o

p q r s t u v

w x y z

LOWER CASE

X-HEIGHT None (height for body of letter optional)
PEN ANGLE None (pointed nib)
LETTER SLOPE 54 degrees
FORM Oval

ASCENDERS Same height as for body of letters
DESCENDERS Same height as for body of letters
SPACING Equal spacing between letters.

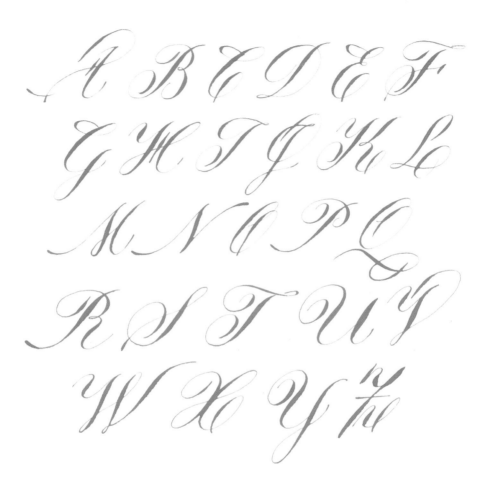

CAPITALS

X-HEIGHT None (height for body of letter optional)
PEN ANGLE None (pointed nib)
LETTER SLOPE 54 degrees
FORM Oval

ASCENDERS None
DESCENDERS For G and Y: as for body height
SPACING Equal area

straight strokes with arches – m

This group is comprised of the letters 'b', 'h', 'k', 'm', 'n' and 'p'.

I Loop upwards then pull the pen down to form a thick stroke, decreasing the pressure in the centre of the stroke.

2 In one movement, work upwards from the bottom of the stroke, then form an arch and downstroke.

3 Repeat the second arch and downstroke, keeping the spacing equal. Finish with an upward loop.

Stroke reminder

diagonals – w

The three diagonal letters are 'v', 'w' and 'z'.

Stroke reminder

I Start with a small upward loop then pull the pen down, increasing the pressure in the centre of the downstroke. Then loop upwards for the upstroke.

2 In a continuous movement, pull the pen down for the second downstroke. Finish the light upstroke with a circular loop below body height.

straight letters – f

The straight letters are 'f', 'i', 'j', 'l' and 't'.

| Start the letter with a lead-in stroke. Make another upward stroke above body height to form the loop.

2 Loop around at the top, then increase the pressure on the downstroke, releasing it before the bottom.

3 In one continuous smooth movement, loop the pen upwards to create a larger bottom bowl.

4 Continue the pen stroke to add the crossbar, above half way.

Stroke reminder

oval letters – a

The oval letters are based on the 'o'. The other letters are 'a', 'c' and 'e'.

Stroke reminder

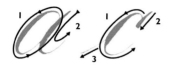

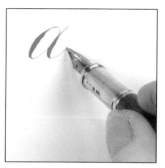

| Working in an anti-clockwise direction, pull the pen down, increasing the pressure for the curve of the bowl. Decrease the pressure and loop upwards.

2 Starting at body height, pull the pen down, increasing the pressure. Loop upwards at the baseline to form the serif.

ovals followed by a straight stem – d

The three letters that make up this group are 'd', 'g' and 'q'.

Stroke reminder

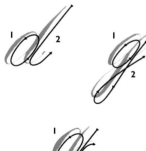

| As for 'a' and 'o', start the letter in an anti-clockwise direction, then pull the pen down, increasing the pressure. Loop the stroke upwards, decreasing the pressure, to complete the bowl.

2 Keeping your stroke angle consistent, start the downstroke, increasing the pressure in the centre of the stroke. Decrease the pressure at the bottom then loop upward.

variants – s

The variants group is comprised of 'r', 's', 'u', 'x' and 'y'. There are two possible types of 'r'.

1 Start with a long, thin upward curve from the baseline to body height. Make a small loop above body height.

2 Increase the pressure on the nib on the downstroke. Finish off with a wide, smooth upward curve.

3 Carefully fill in the top loop to make it a solid colour.

Stroke reminder

putting it all together

Copperplate capitals

letters starting with a flourish – W

'C', 'E', 'S', 'U', 'V', 'W', 'X' and 'Z' are the letters that make up this group.

1 Begin with an upward stroke and oval loop. Form a thick downstroke and a second upward loop for the bowl.

2 Increase pressure in the centre of the downstroke to create the tail of the letter, adding a small loop at the end.

3 In the same movement, make an upward sweeping curve, loop over, and make a heavy downstroke, as before.

4 Starting above body height, pull the pen down in a thick, sweeping curve to join the bottom loop.

Stroke reminder

letters descending below the baseline – G

'G' and 'Y' are the only letters with descenders that go below the baseline.

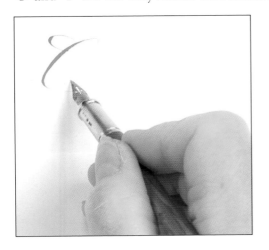

1 | Start with an oval loop and continue in a downward curve for the body of the letter, placing pressure in the centre of the stroke and ending with an upward curve.

2 In the same movement, pull the pen down to form the thick stroke of the tail before finishing the tail with loop.

Stroke reminder

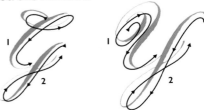

downward movement (thick stroke) – F

Half the alphabet – 'B', 'D', 'F', 'H', 'I', 'J', 'K', 'L', 'O', 'P', 'Q', 'R' and 'T' – makes up this group, which starts with a downward stroke.

1 Starting from the top, pull the pen down in a flat curve, increasing the pressure in the centre of the stroke to create a heavier line.

2 Smoothly loop the pen up and around to form a long tail.

3 Working from the left, form a wide arc, finishing with a small loop that joins the top of the vertical stroke of the letter.

4 Add a decorative crossbar, starting from the tail, sweep up in a gentle curve, finishing with a short downstroke.

Stroke reminder

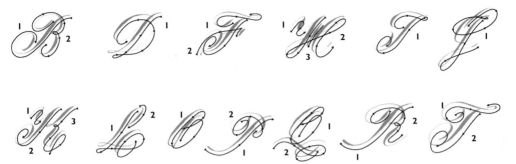

upward movement (thin stroke) – N

'A', 'M' and 'N' are the letters in this group, which start with a downward stroke.

1 Start the letter with a long upward curve. Pull the pen down in a curve, with pressure in the centre of the stroke.

2 In a continuous movement, create another long upward sweep, extending slightly above body height.

Stroke reminder

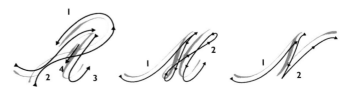

Gallery

Once you have mastered the basic hands, the possibilities for calligraphers are endless. These pages show a range of different hands, used for greetings cards, as artwork to hang on the wall and as books and keepsakes.

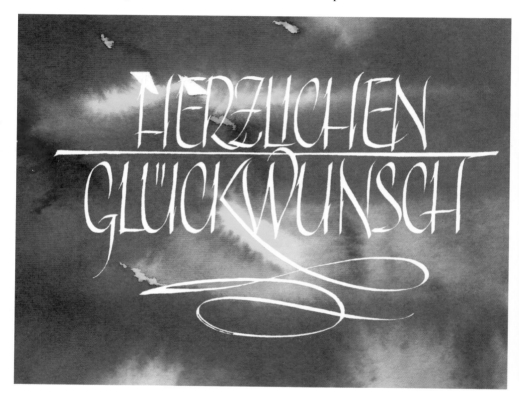

"Herzlichen Glückwunsch"

Jean Larcher

Written using a Speedball nib and gouache, the calligraphy was then reversed out to white on a computer and added to the watercolour background on screen. The card, one of a series, was then offset printed.

"Frohe Weihnachten und Alles Gute im Neuen Jahr"

Katharina Pieper

This is lettered in wood stain using a ruling pen. The calligraphy was reversed and matted to the watercolour background on computer.

Frohe Weihnachten und Alles Gute im Neuen Jahr

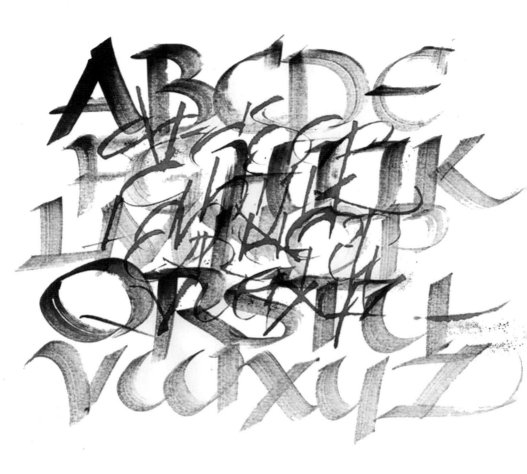

"Alphabets Overlaid"

Mary Noble

The main alphabet was written with a pen cut from balsa wood; its absorbency makes soft textural marks. The looser lettering on top was written with a ruling pen at speed, with frequent dipping to ensure plenty of ink and to contrast with the background alphabet.

"Why Love?"

Nancy Ouchida-Howells

The text, the author's own words, was written using broad-edged pens in watercolours. Some areas were written with art masking fluid covered with a watercolour wash using a chisel brush and then removed to reveal the calligraphy. The gold squares are 23.5 carat gold leaf with a size base of gum ammoniac – the traditional way to apply gold leaf.

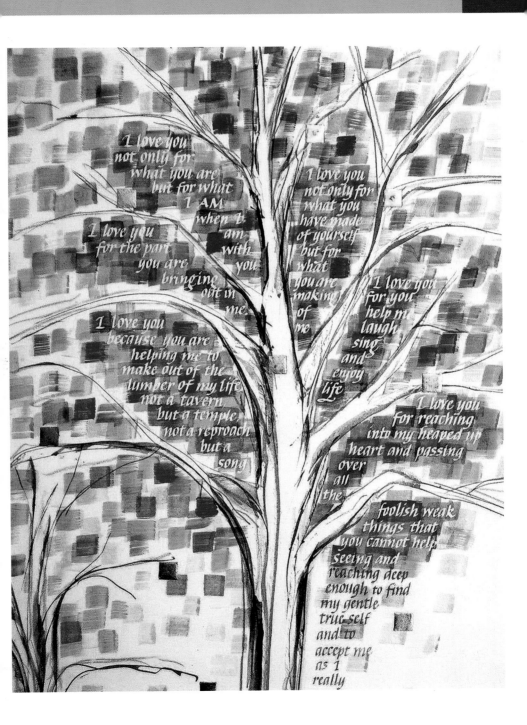

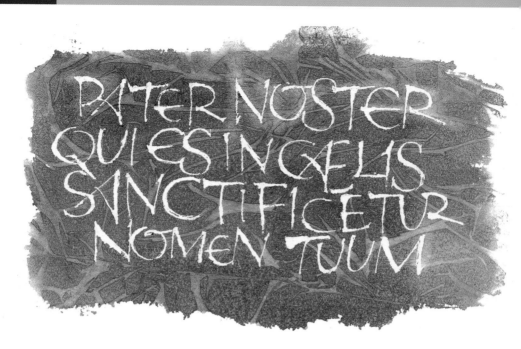

"Paternoster"

Margaret Morgan

The capitals were written with a pen, handmade from a cola can, and masking fluid on stretched rough-surface watercolour paper. When dry, a wash of alizarin crimson and purple lake gouache was flooded over the letters. Clingfilm was laid over the top and pinched into random patterns. The masking fluid was then removed using a cut piece of plastic eraser.

"Alles Gute"

Jean Larcher

The calligraphy for this card was created with a Gillot 303 nib using black gouache on a white background, then touched up. The text was reversed out to white on computer and added to the watercolour background.

"Almost g"

Margaret Morgan

A small amount of gouache was poured onto the paper, then 'pushed' into shape using a chisel-edged colour shaper.

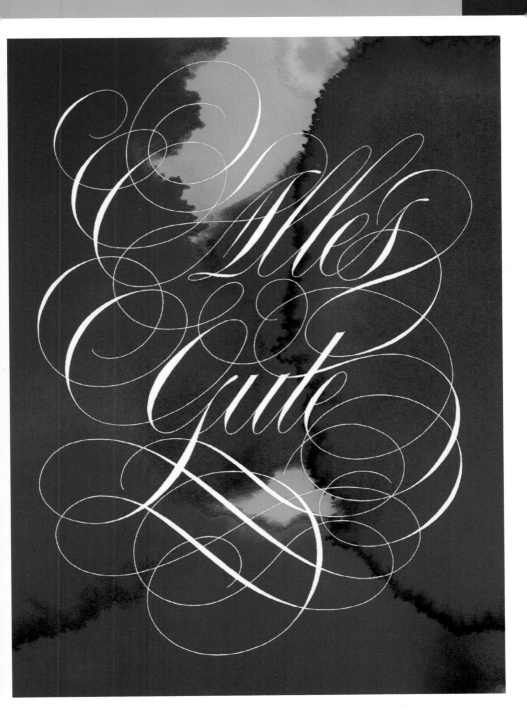

Index

Thanks to my family for their support.
My thanks also to my former teachers,
especially Gaynor Goffe, who have been
so supportive and given of their
knowledge so generously.